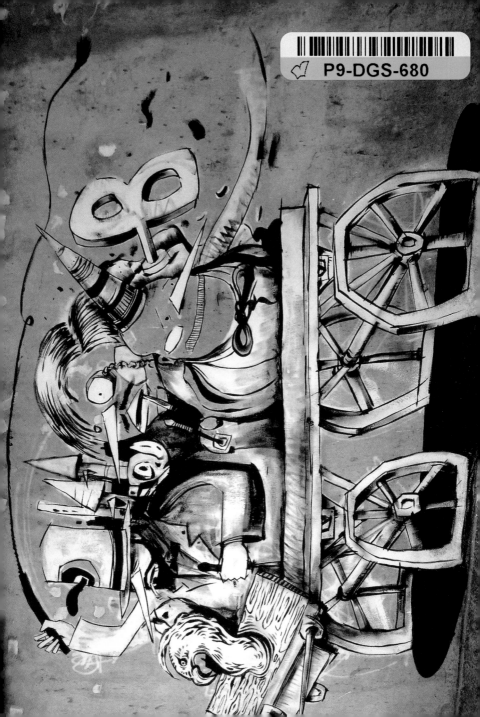

Street Art

the best urban art
from around the world

compiled and
introduced by KET

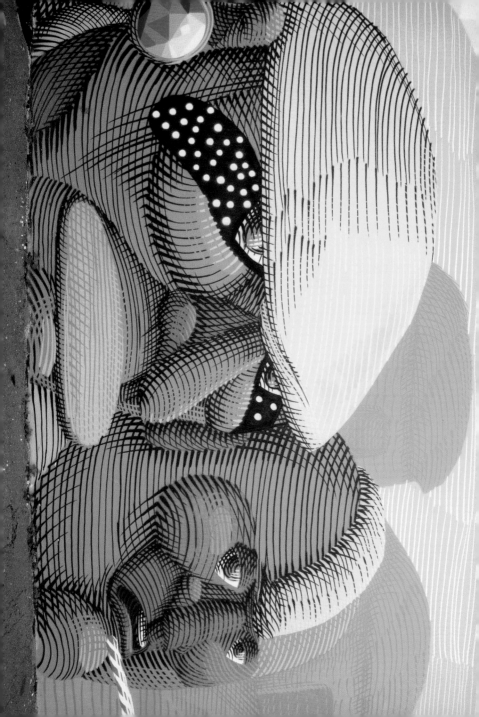

Street Art

**the best urban art
from around the world**

compiled and
introduced by KET

Michael O'Mara Books Limited

First published in Great Britain in 2011 by
Michael O'Mara Books Limited
9 Lion Yard
Tremadoc Road
London SW4 7NQ

A CIP catalogue record for this book is available from the British Library.

Papers used by Michael O'Mara Books Limited are natural, recyclable products made from
wood grown in sustainable forests. The manufacturing processes conform to the environmental
regulations of the country of origin.

ISBN: 978-1-84317-521-6

1 3 5 7 9 10 8 6 4 2

www.mombooks.com

Page 2 image: Nunca, Miami, Florida, USA
Page 5 image: Oil by Daks, Miami, Florida, USA
Endpapers: Swansky, London Police and Morcky, Tirana, Albania (front)
Titi Freak, Sao Paulo, Brazil (back)

The author and publisher have made every effort to contact all copyright holders of these images.
Any errors or omissions that may have occurred are inadvertent and will be corrected in subsequent
editions if notification is sent to the publisher.

Designed by Joanne Omigie (joanneomigie.com)

Printed and bound in Singapore by Tien Wah Press Pte Ltd

Dedicated to the memory of OIL COD crew.

Special thanks to Andrea and Talia for the ongoing love and support, Kid Acne and Wane for the contacts and to all the artists who travel to spread their love and art. Keep it going.

introduction

I first encountered what is today considered 'street art' as a young graffiti writer in New York in the 1980s. Richard Hambleton's shadow men could be seen throughout all the Lower Manhattan's parking lots and stood out amongst all the tags, throw-ups, and pieces that normally occupied those spaces. The artist group Avant, as well as punk rockers and clubs, were pasting painted posters across the city.

By the late 1980s Ronnie Connal's political posters, an attack on the war-friendly politicians of the time, were emerging, sparking national controversy. At this time the graffiti movement remained separate from the street art scene, despite often sharing the same walls. The graffiti writers had little respect for the street artists, an attitude that began to change as both scenes started to exhibit in the same downtown galleries.

While the street artists entered the galleries, graffiti writers emerged from the tunnels and started bombing the streets of the city again. Writers like Chino, Trim, Easy and Cope2, who were

all part of the train movement, now turned to the city as their canvas. It was not until the 1990s that a new wave of street art emerged in the US, with Cost and Revs bombing the city with stickers, posters, and roller paint. Their controversial statements were bright spots in a city too covered in corporate advertising. It took artists like Shepard Fairey to fully bring street art to a wider audience. Able to adapt to the streets like a writer, Fairey's message was different; it had humour, it was weird: 'Andre the Giant has a posse'. This small campaign blew up nationally, paving the way for thousands of copycats.

Meanwhile in Paris there was already an old tradition of artists adorning the streets with figures and stencils. In the 1960s artists like Gérard Zlotykamien painted ghostly silhouettes and in the 1980s Blek Le Rat, now considered a pioneer in the scene, began painting images of the homeless in Paris. His work influenced the next generation of stencil artists like fellow Parisian Poch and Banksy in the UK.

No longer are graffiti writers alone in decorating the streets. Yet they paved the way for other artists to see the streets as a means of displaying their work for free. Graffiti murals now sit alongside those of street artists as well as graffiti writers like Barry McGee

who blur the lines between both movements.

This book celebrates those who use the streets as their canvas and who risk incarceration to create art. Here you will find many unsanctioned works that remain true to the outlaw spirit of graffiti. Some artists featured have studio practices and some display in galleries while others remain rooted in the streets.

An incredible, vandalistic art movement is happening all around us. Look around you and you might catch one of the works produced by the artists within this book. Take a moment to contemplate its beauty – it just might brighten your day.

Peace,

Ket

right
REVS and PEAK | Brooklyn, NY, USA. Photo by Ket

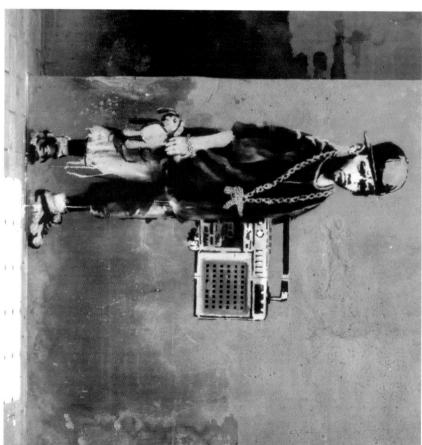

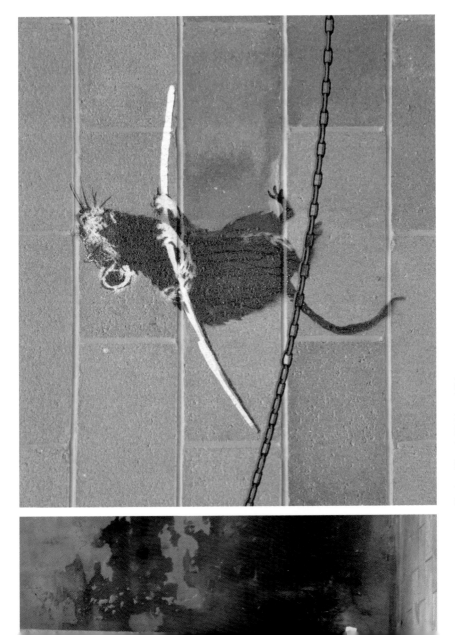

Banksy | Detroit, Michigan, USA

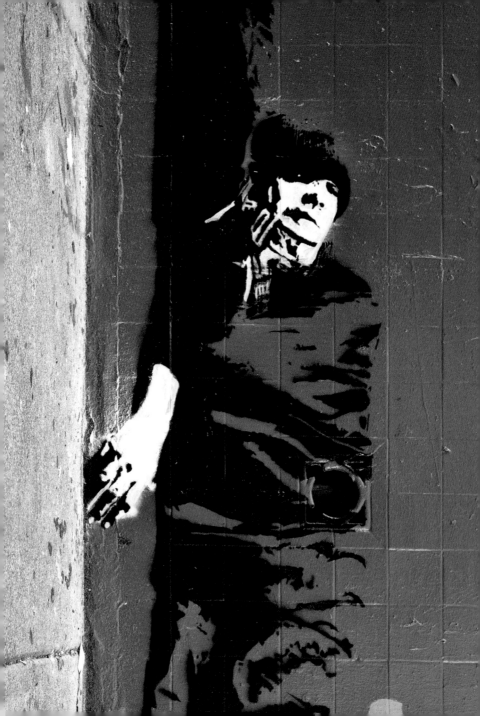

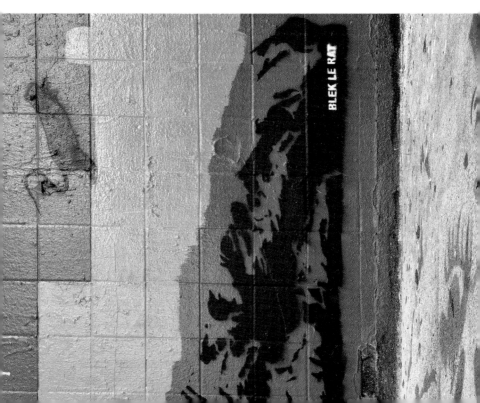

Blek Le Rat | San Francisco, California, USA.
Photo by Troy Holden

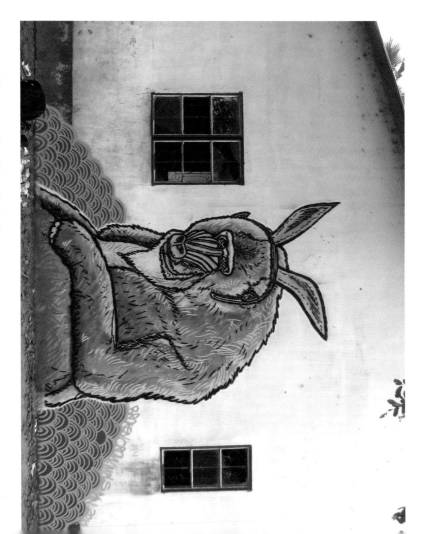

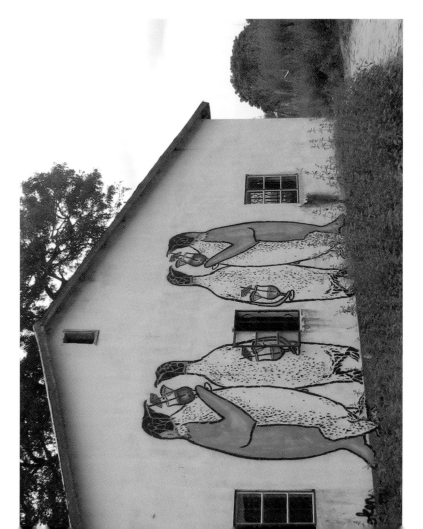

Penguins by **Broken Crow** | Kubuneh, Gambia

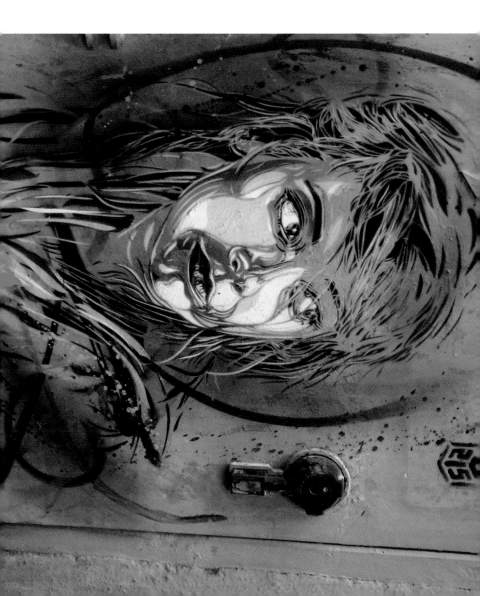

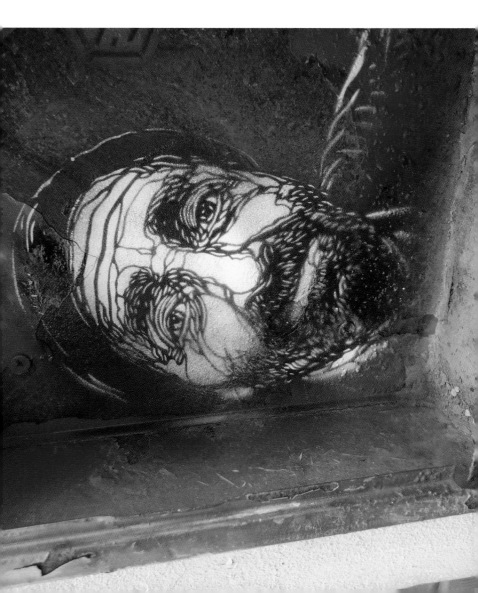

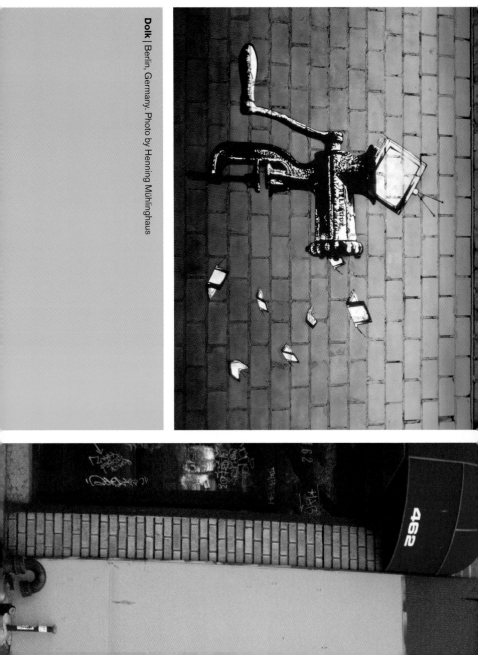

Dolk | Berlin, Germany. Photo by Henning Mühlinghaus

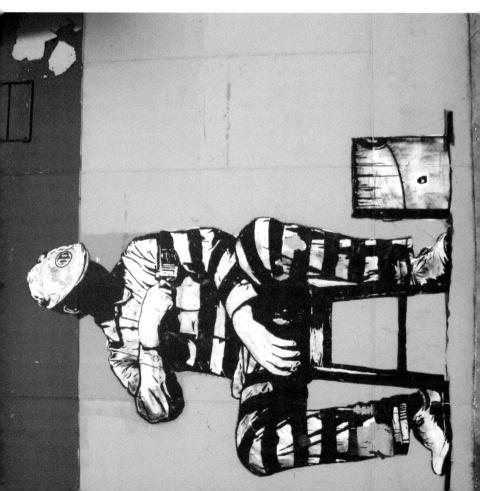

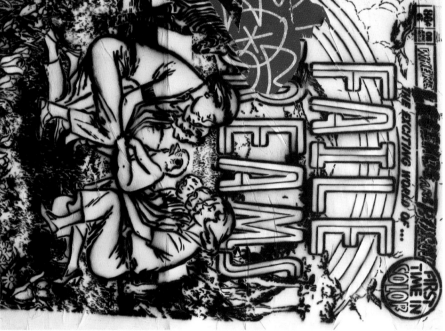

left & right
Faile | Brooklyn, New York, USA.
Photos by Ket

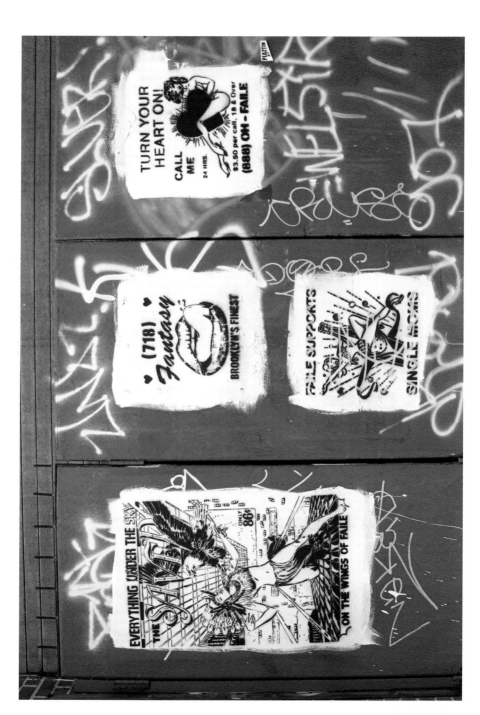

Jef Aérosol | Paris, France. Photos by Ket

opposite
Have Fun Before It's Too Late by Jef Aérosol |
Brooklyn, New York, USA. Photo by Becki Fuller

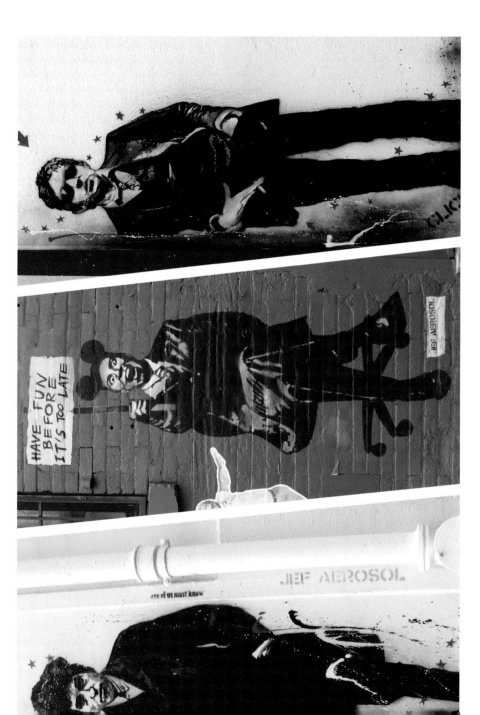

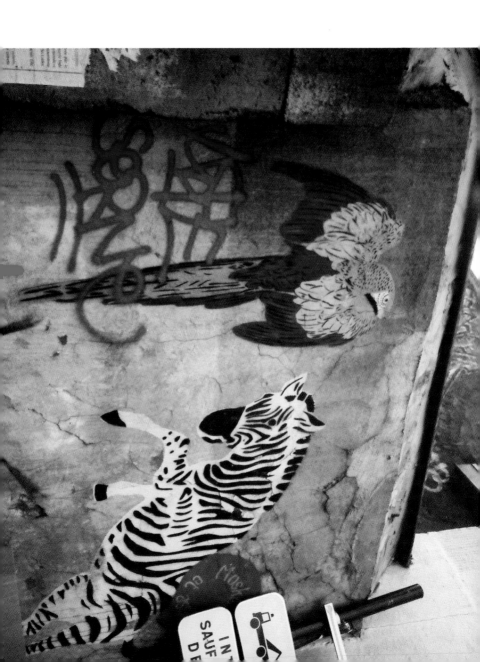

Mosko et Associés | Paris, France.

Photos by Ket

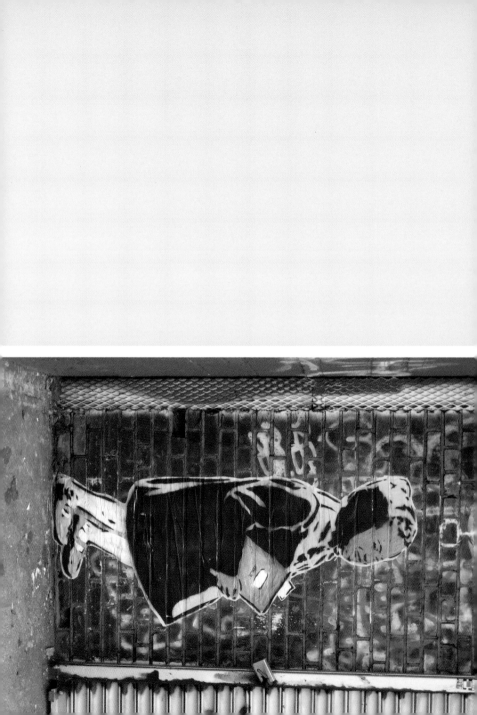

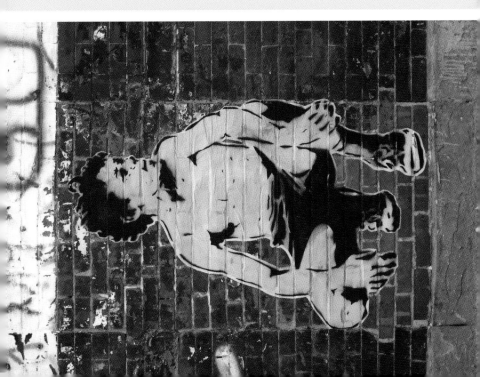

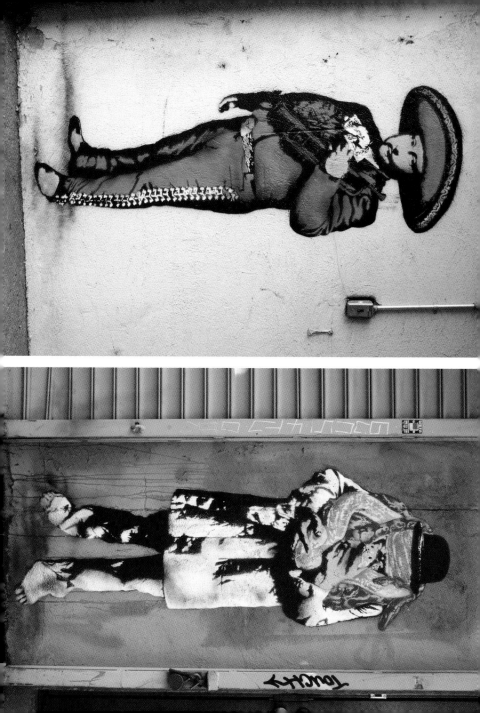

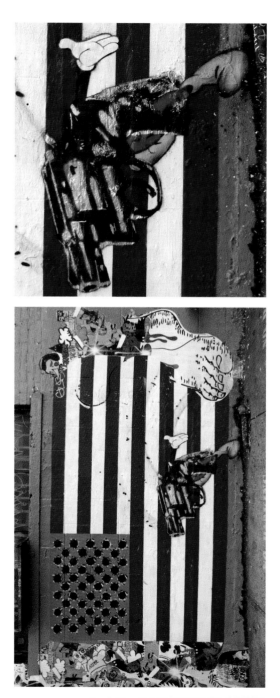

Amerikarma by Nick Walker | Brooklyn, New York, USA. Photo by Ket

opposite
Nick Walker | Brooklyn, New York, USA. Photos by Ket

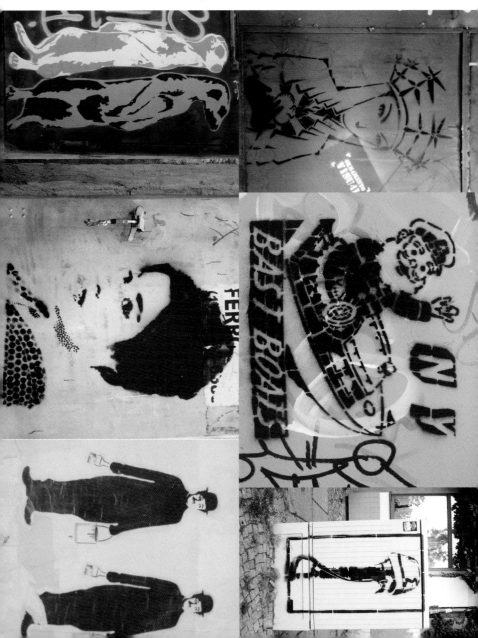

Stencils from around the world. All photos by Ket

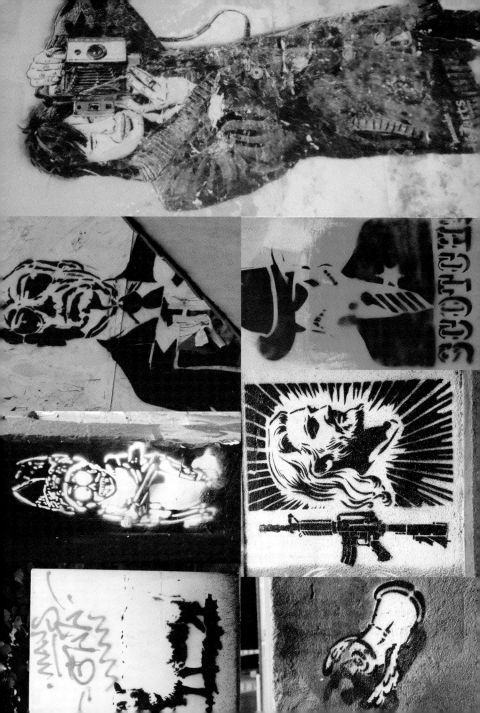

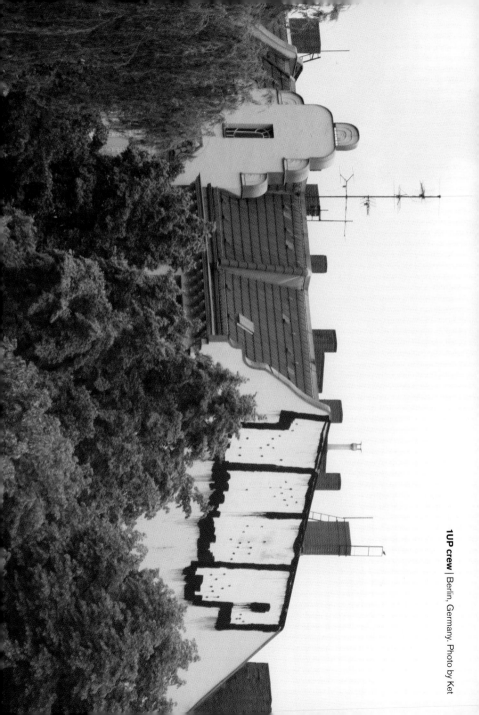

1UP crew | Berlin, Germany. Photo by Ket

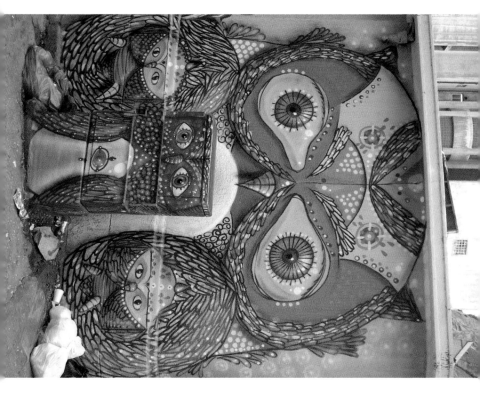

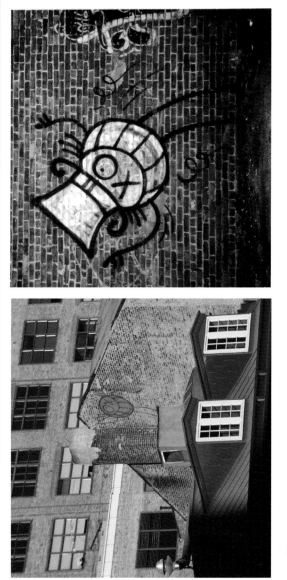

André | Brooklyn, New York, USA. Photo by Ket

André | New York City, New York, USA. Photo by Ket

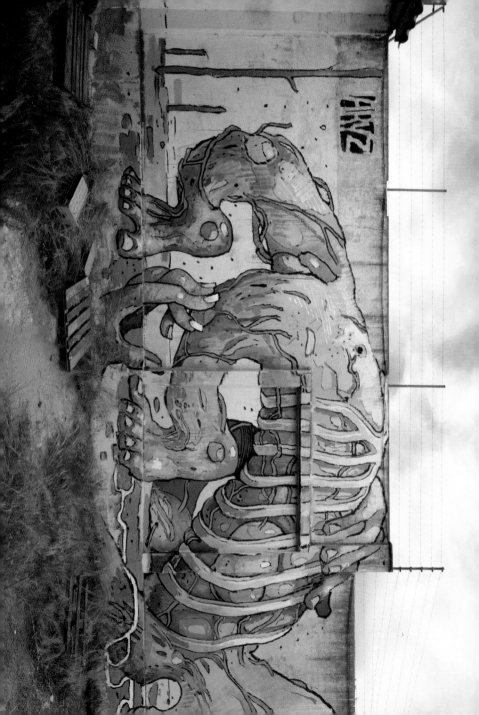

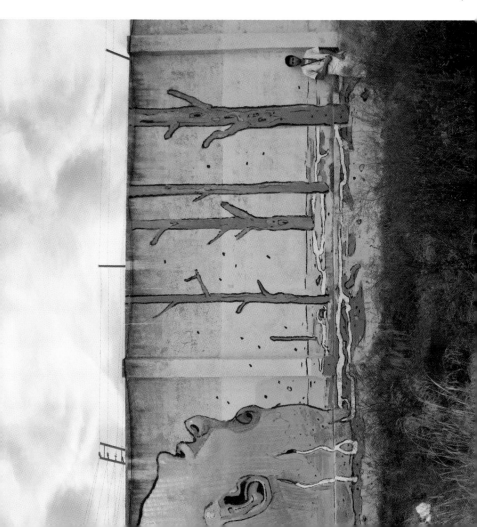

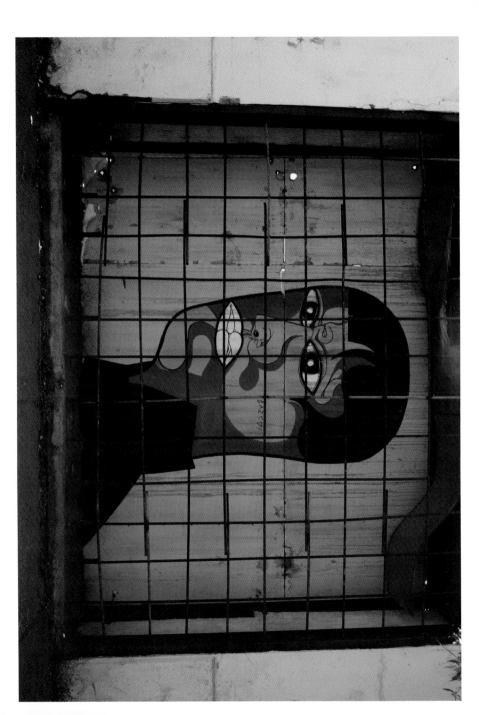

left
Encerrado by Basco Vasco | Santiago, Chile

right
Amante Egipcio by Basco Vasco | Santiago, Chile

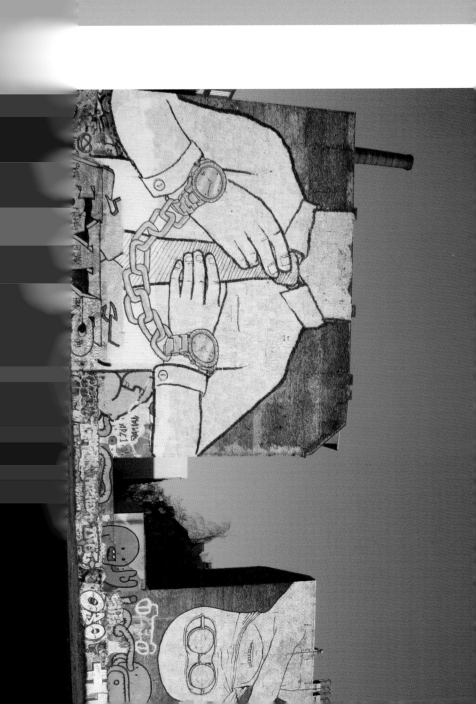

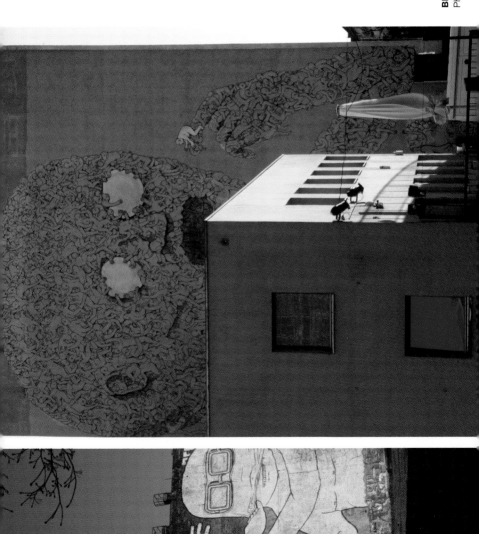

Blu | Berlin, Germany.
Photos by Ket

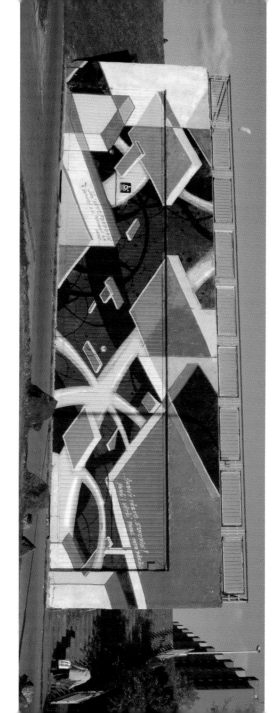

Cakes | Prague, Czech Republic

Cakes as Onepoint | São Paulo, Brazil

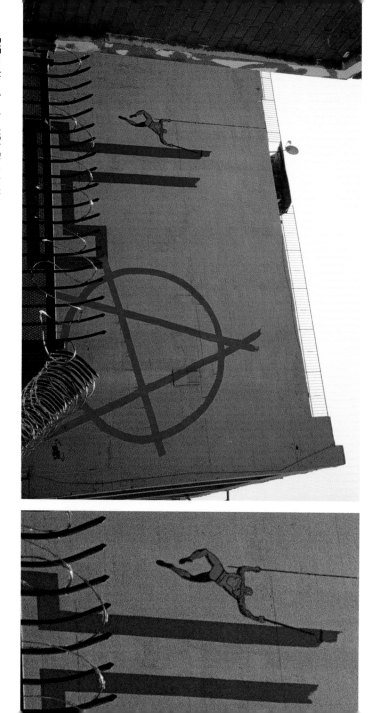

Detail of a D*Face wall | New York City, USA. Photo by Ket

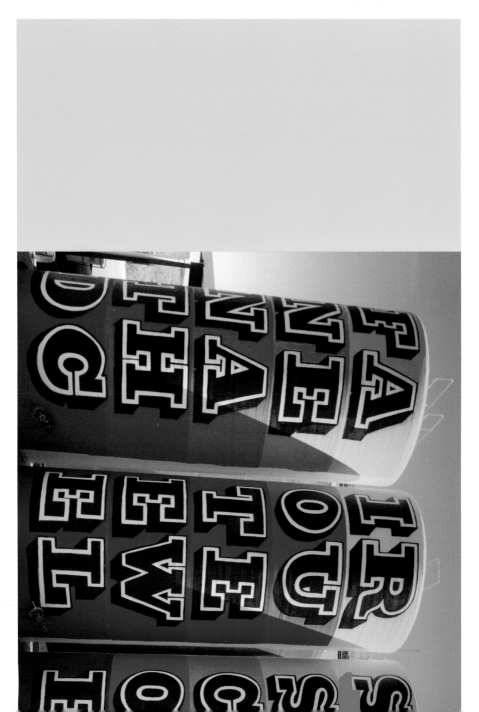

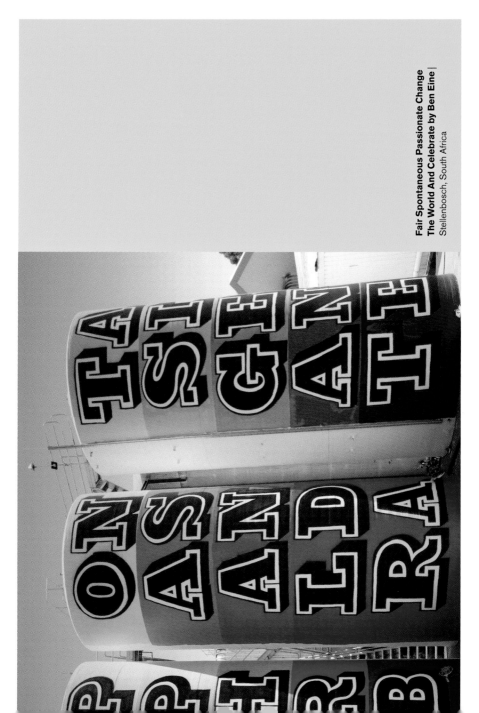

**Fair Spontaneous Passionate Change
The World And Celebrate by Ben Eine |**
Stellenbosch, South Africa

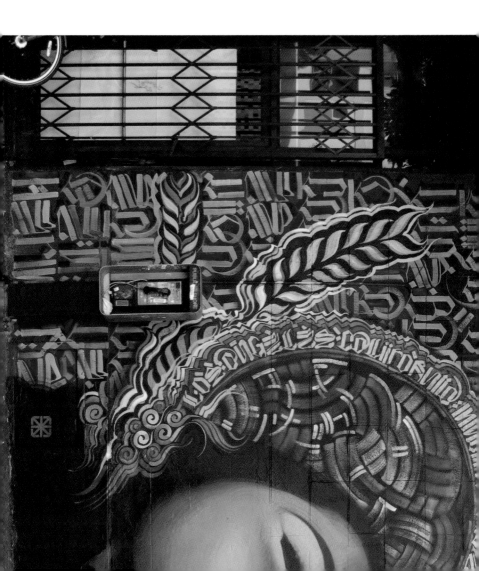

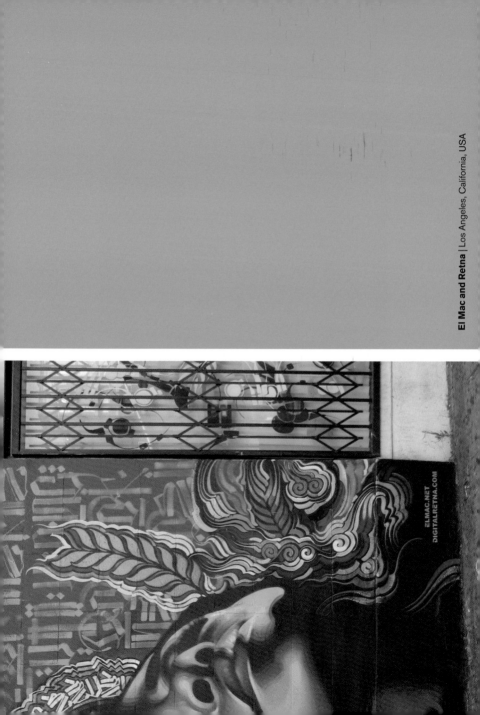

El Mac and Retna | Los Angeles, California, USA

ELMAC.NET
DIGITALRETNA.COM

Eltono | São Paulo, Brazil

Eltono | Tampiquito, Monterrey, Mexico

Eltono | Lima, Peru

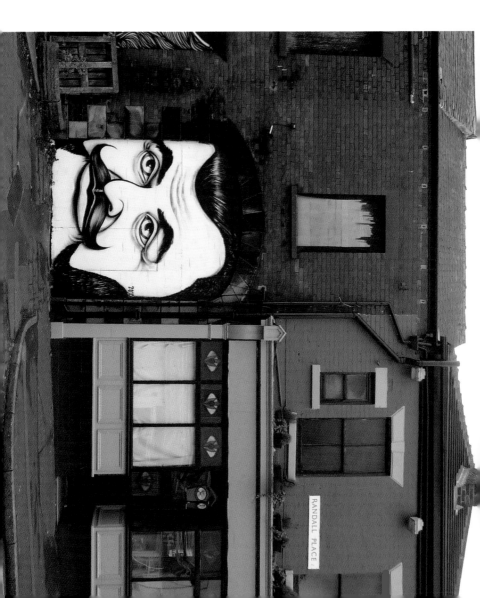

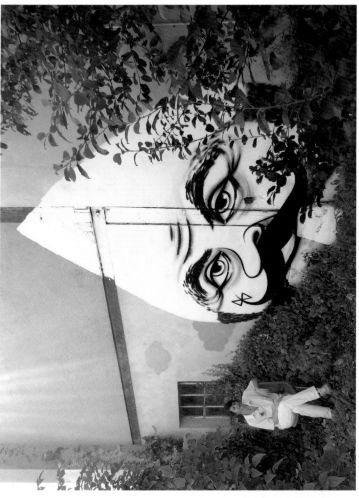

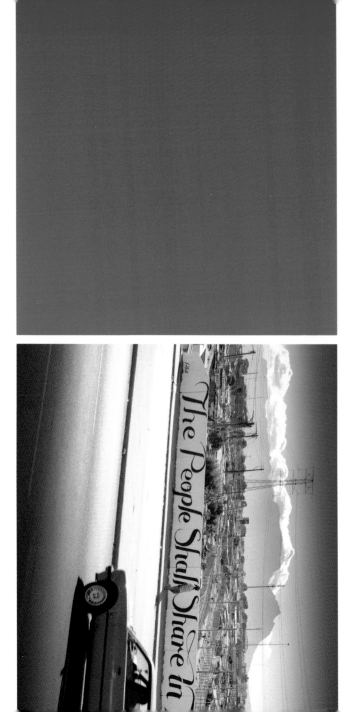

Faith47 | Khayelitsha, Cape Town, South Africa. Photo by Rowan Pybus

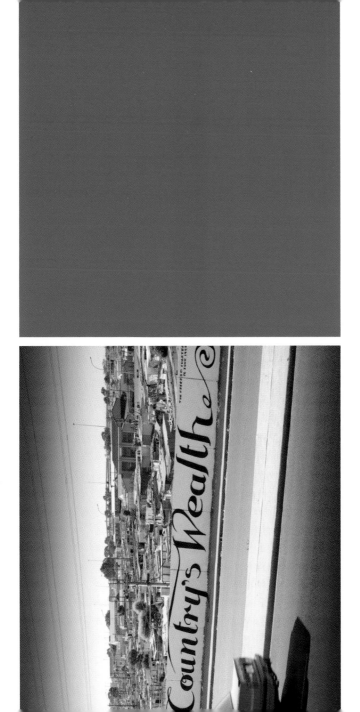

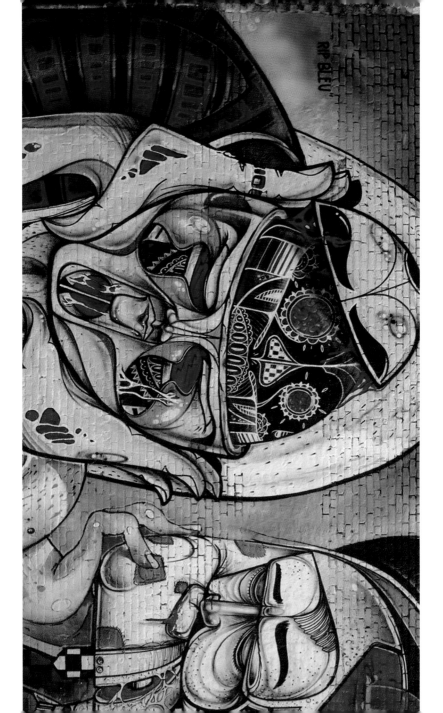

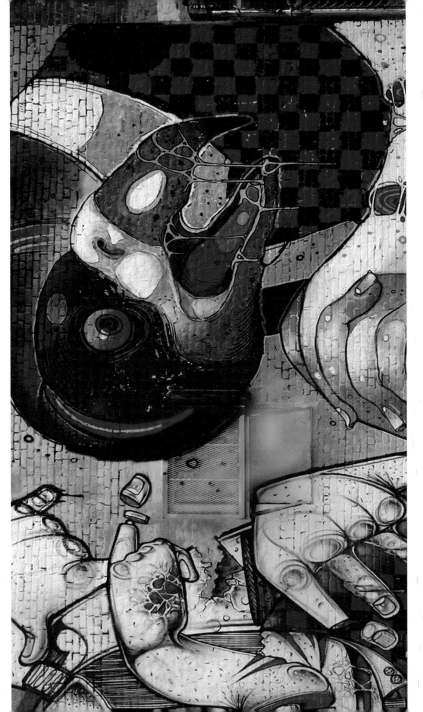

How and Nosm and Ayrz | Brooklyn, New York, USA

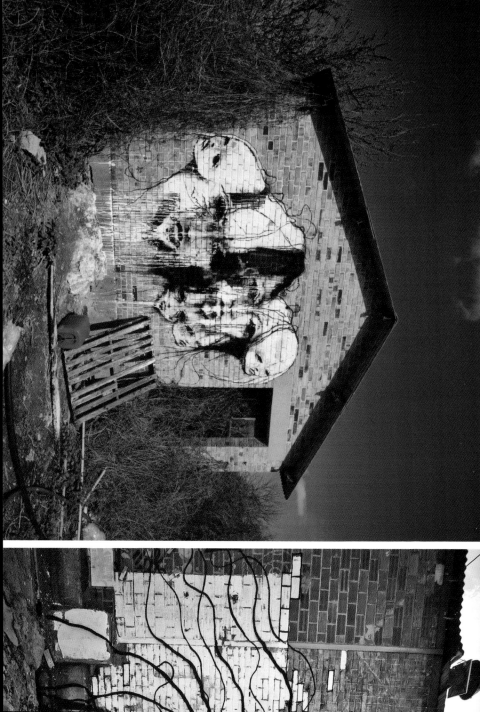

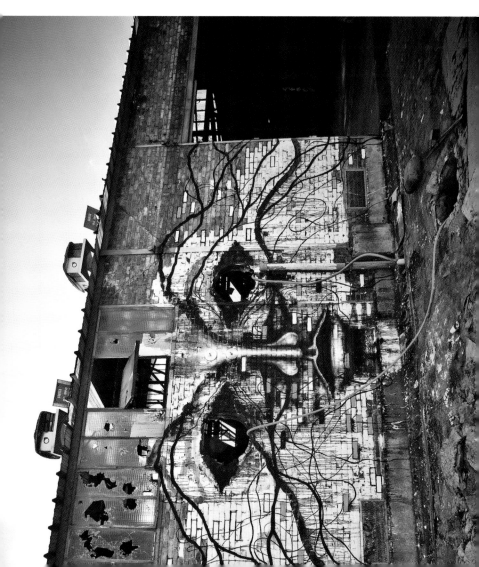

Iemza | Reims, France.
Photos by M.T.G

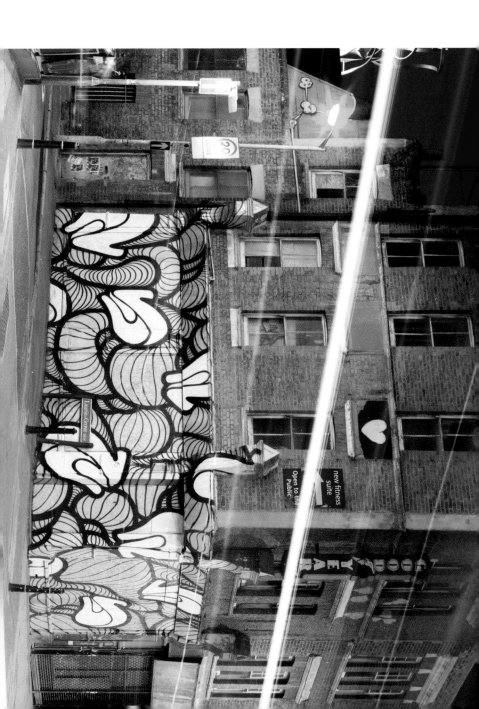

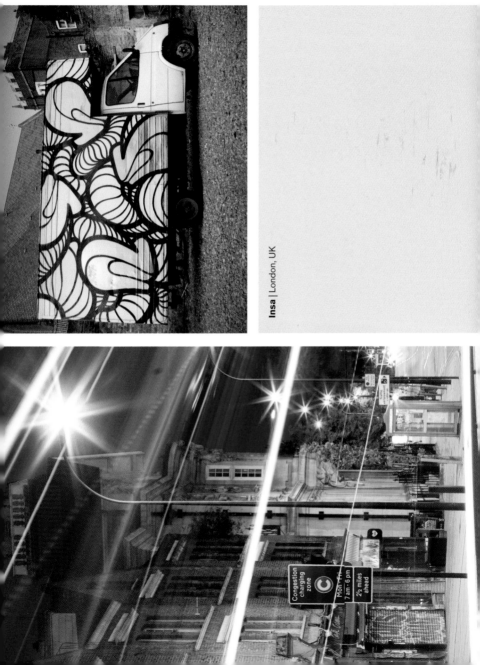

Insa | London, UK

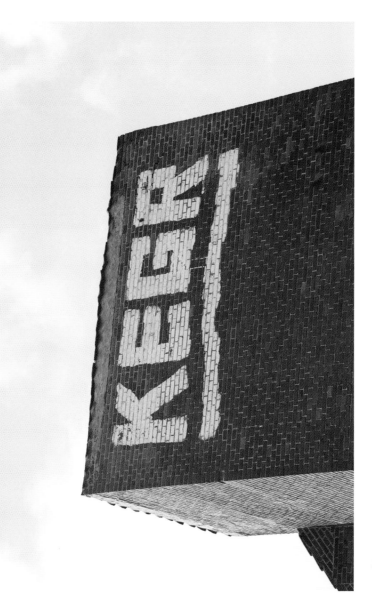

Kegr | Copenhagen, Denmark. Photos by Ket

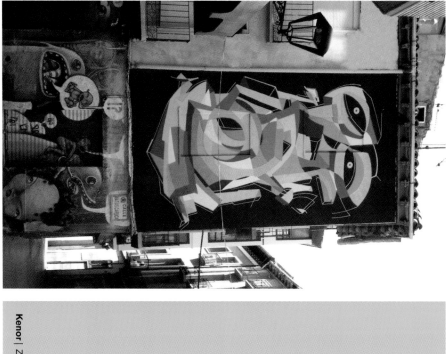

Kenor | Zaragoza, Spain

Kenor | Barcelona, Spain

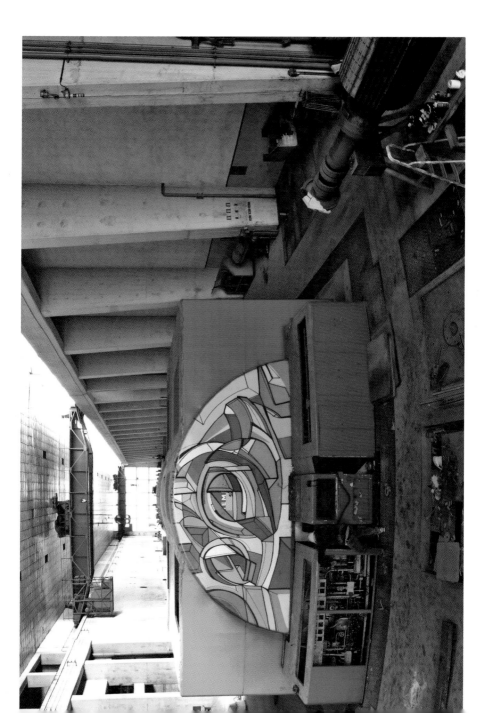

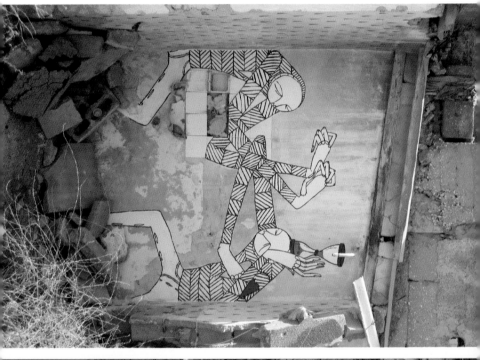

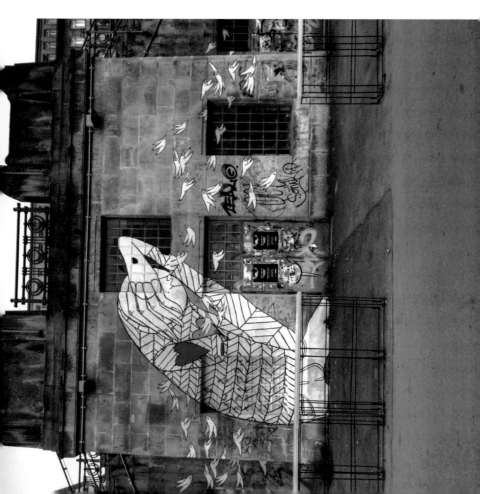

**And the Patterns Spoke
of a Certain Certainty by Know
Hope** | Vienna, Austria.
Photo by Harald Wolfbeisser

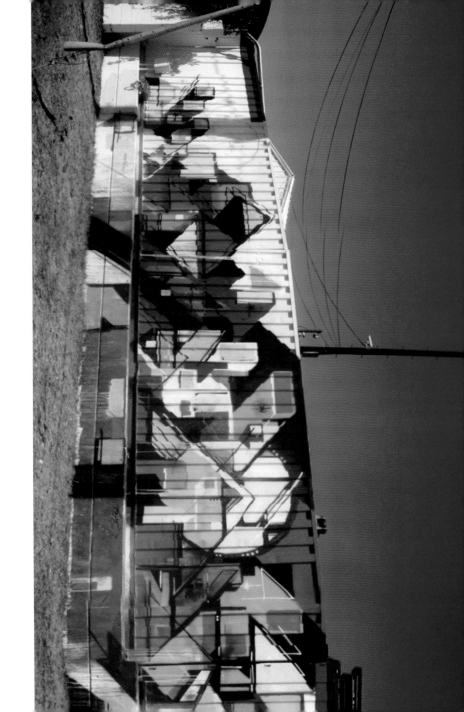

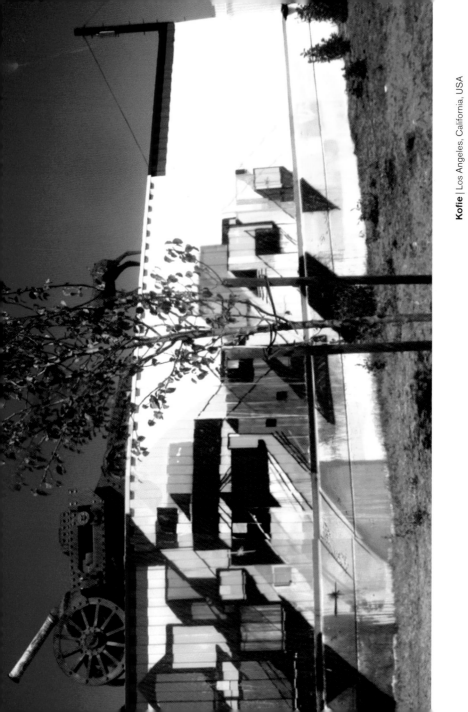

Kofie | Los Angeles, California, USA

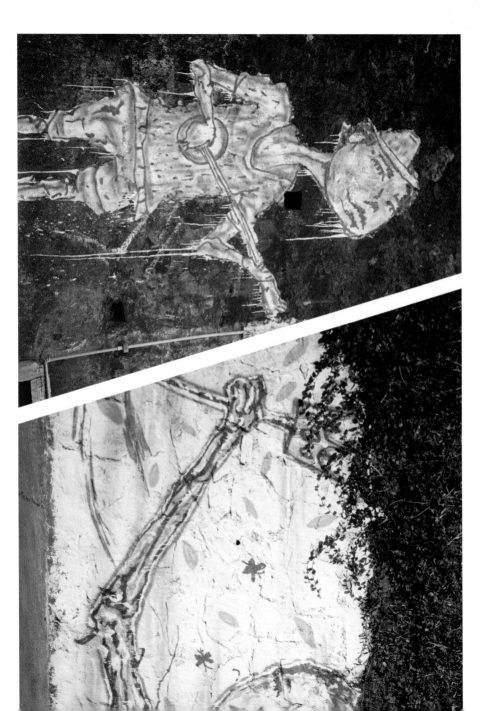

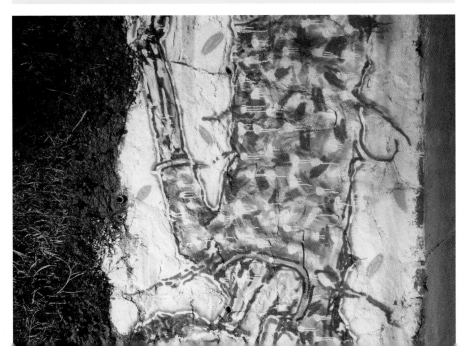

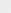

left
Limpo | Salvador, Bahia, Brazil. Photo by Ket

right
Detail of a Limpo mural | Salvador, Bahia, Brazil.
Photo by Ket

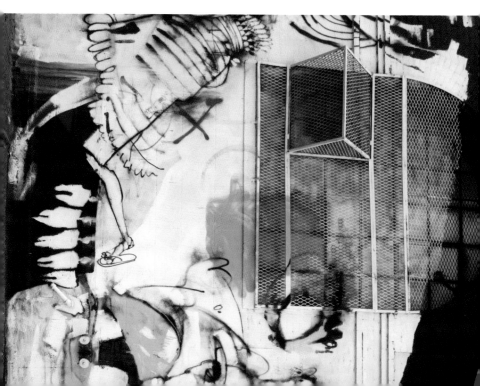

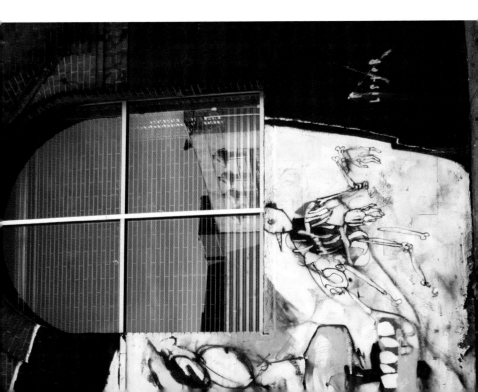

Anthony Lister | Brooklyn, New York, USA. Photo by Ket

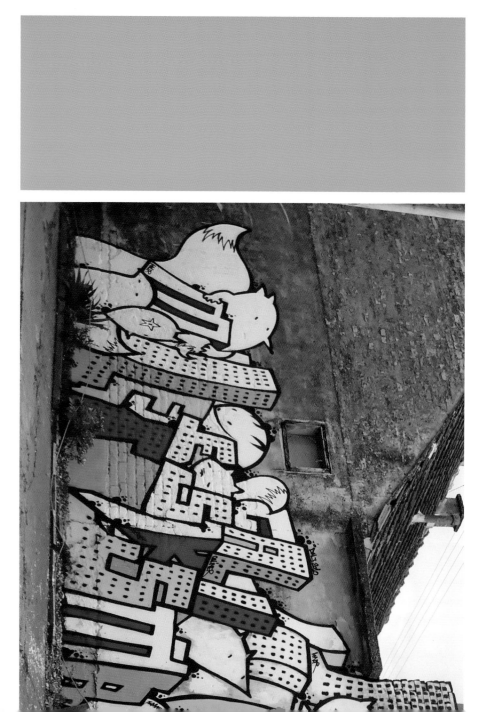

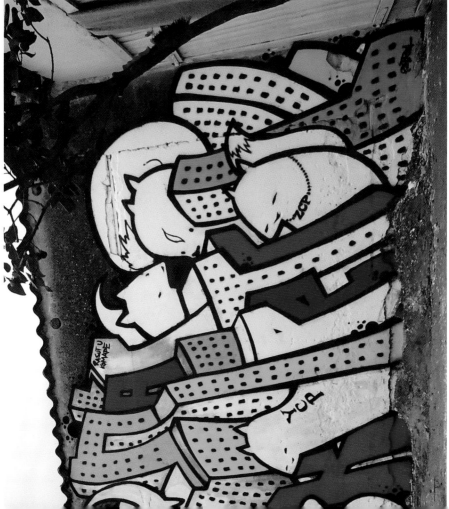

Barry McGee | Miami, Florida, USA.
Photos by Ket

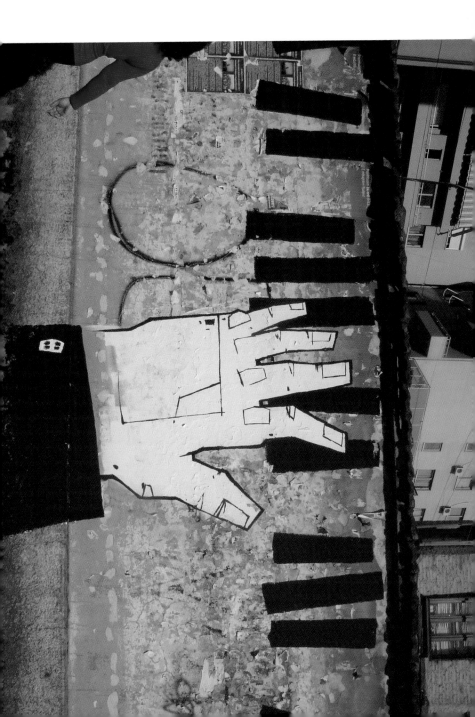

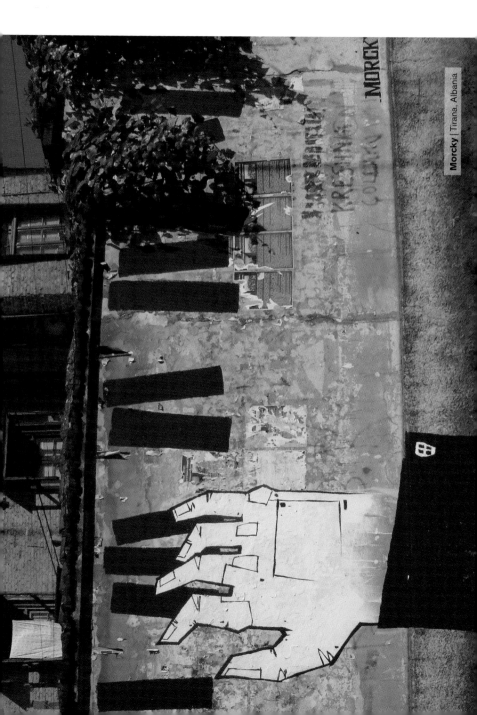

Morcky | Tirana, Albania

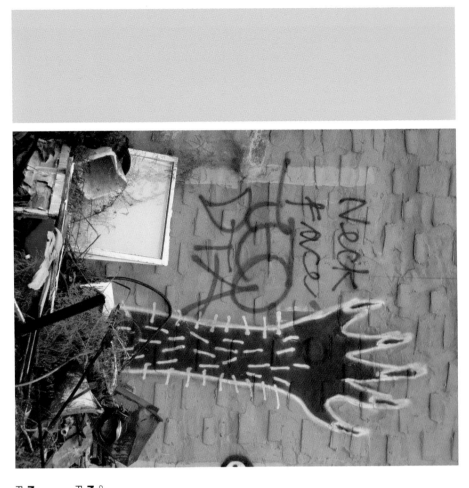

opposite page
Neckface | Brooklyn, New York, USA.
Photo by Luna Park

Neckface | Brooklyn, New York, USA.
Photo by Ket

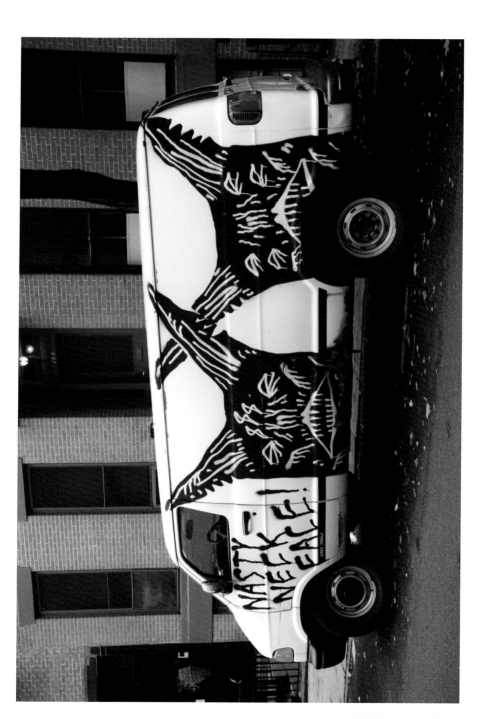

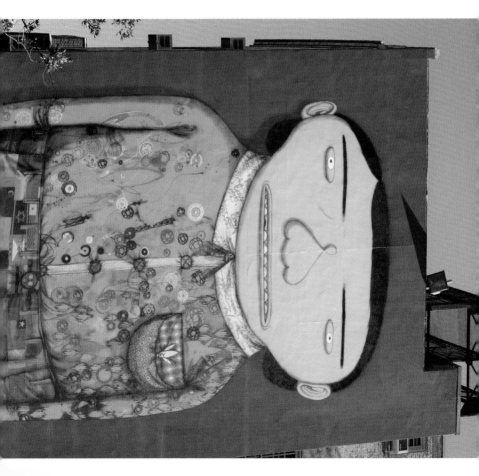

Detail of a mural by Os Gêmeos and Futura | New York City, New York, USA.
Photo by Ket

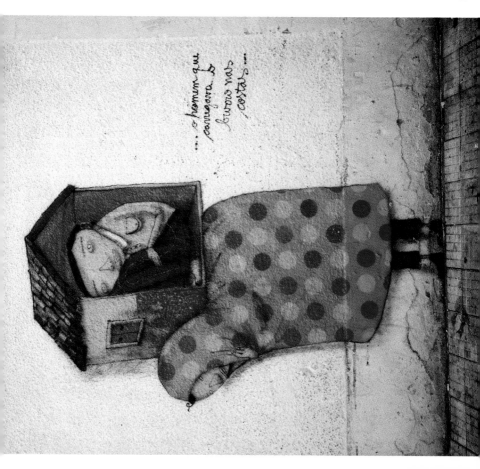

Os Gêmeos | São Paulo, Brazil. Photo by Ket

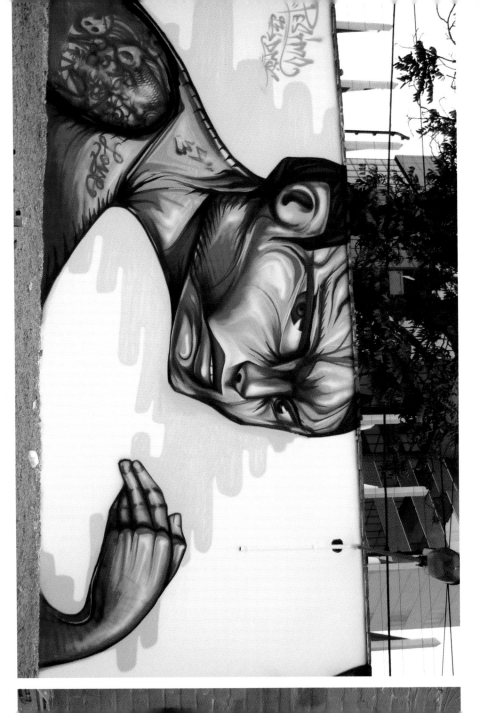

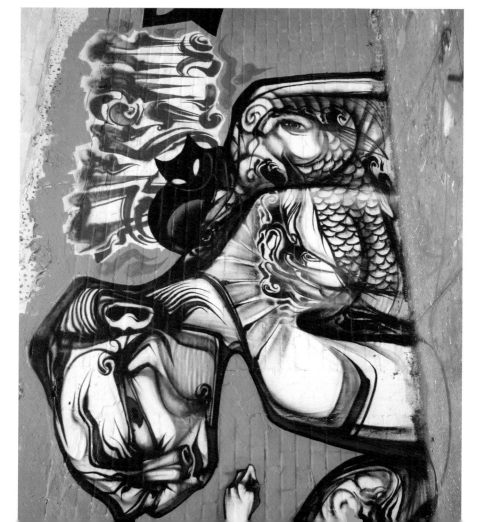

Pøbel and Atle Østrem | Stavanger, Norway

Peace | Salvador, Brazil. Photo by Ket

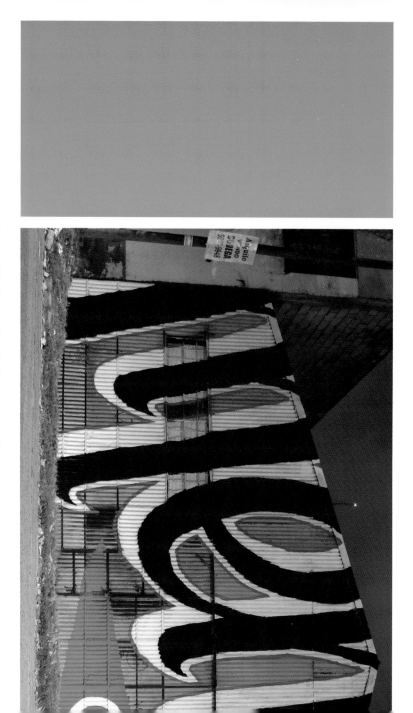

Menos o Más (Less or More) by Ripo | Guatemela City, Guatemala

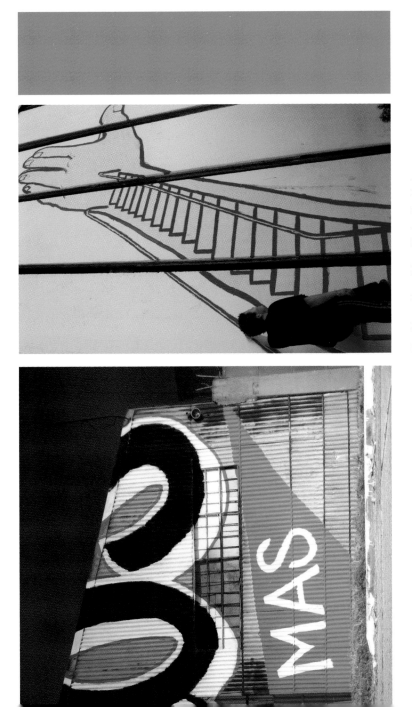

Ripo | Santa Marta Prison, Mexico City, Mexico

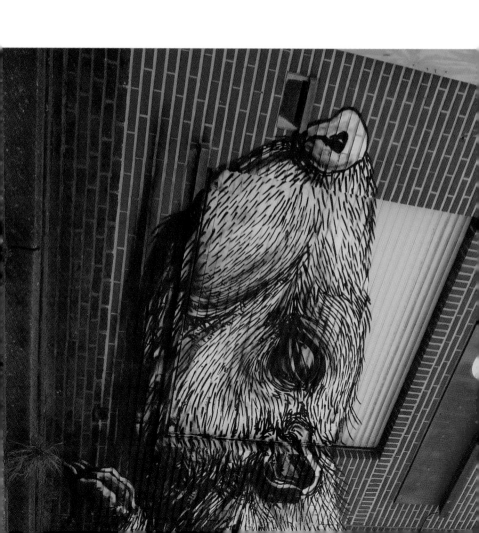

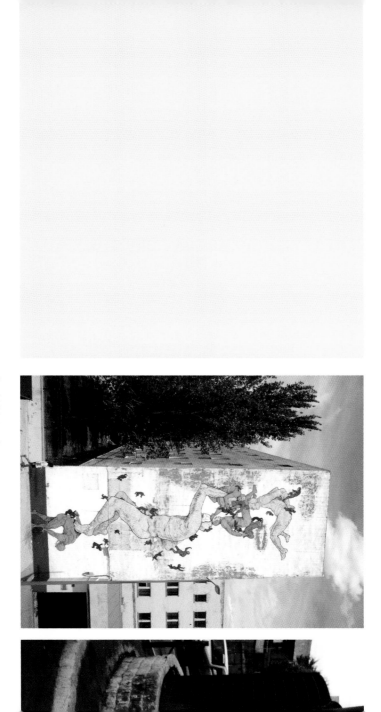

Zezão | São Paulo, Brazil. Photo by Ket

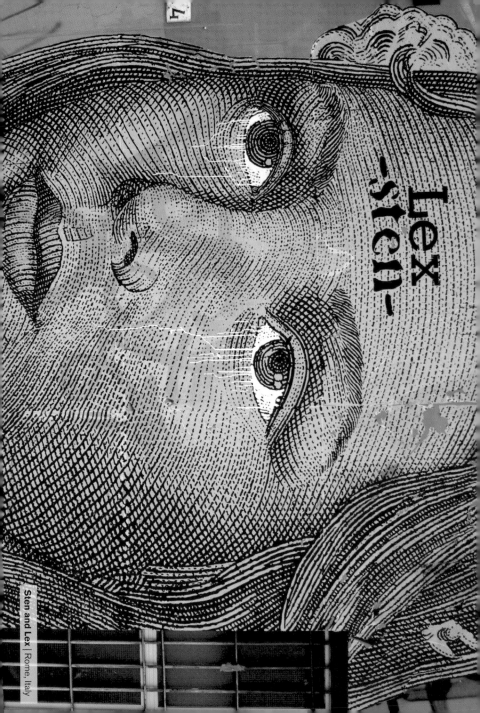

Lex -sten-

Posters/
Wheat Paste

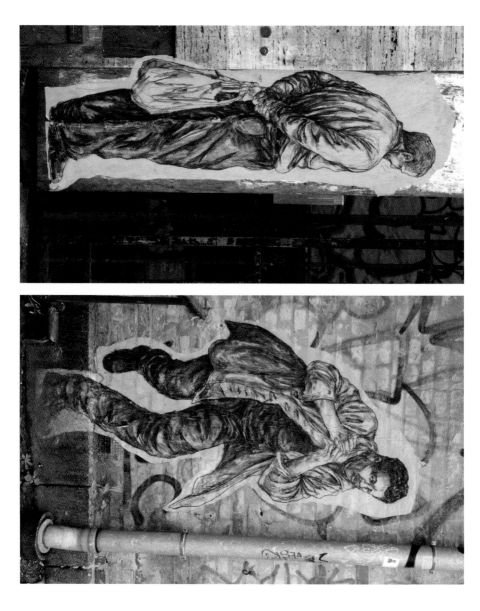

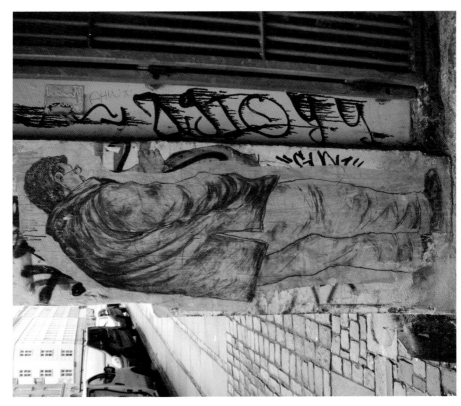

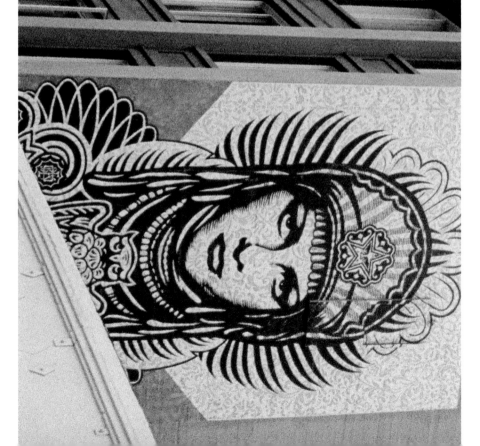

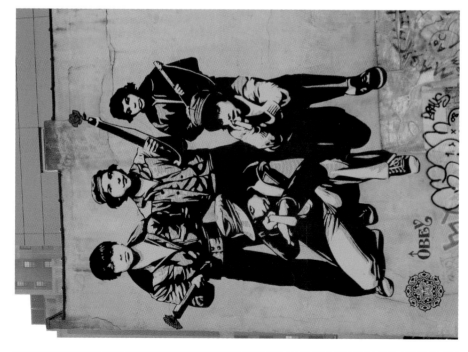

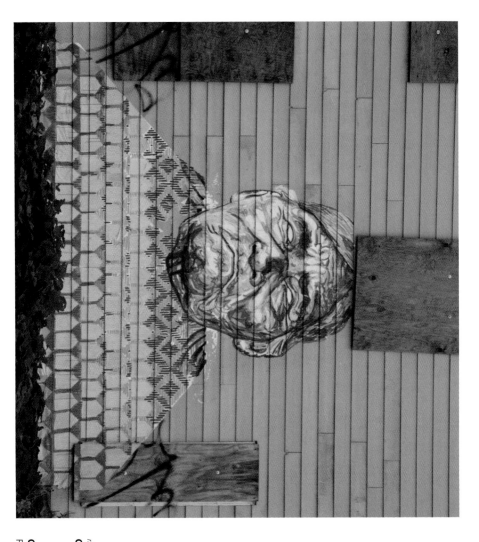

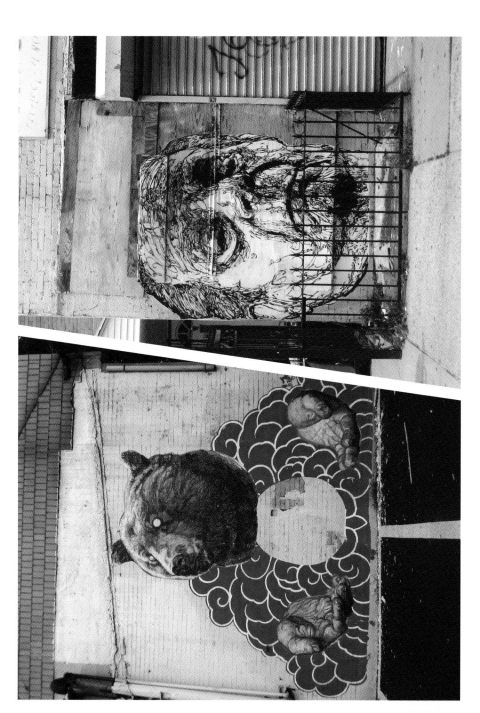

A TALE OF OVERWHELMING DISASTER.

NEW YORK CITY DEALT A FATAL BLOW

GREAT FIRE

OF 1835

SPARKS ON 17 DEGREE DECEMBER NIGHT

674 BUILDINGS DESTROYED TO CINDERS

BY

RAGING FLAMES

NOT A BUILDING STILL STANDS

BETWEEN WALL STREET AND PEARL STREET

MILLIONS OF DOLLARS IN SILKS, FURS & LIQUOR INCINERATED

TEN THOUSAND BOTTLES OF CHAMPAGNE

CONSUMED BY MOBS OF THIEVES AND LOOTERS

ONE OF TWO TRAGIC DEATHS AFTER

2 DAY FIRE RAGES ACROSS MANHATTAN

ORGANIST

MEETS HIS SUDDEN DEMISE

PLAYING A FUNERAL DIRGE

INSIDE FLAMING

GARDEN ST BUILDING

AS IT COLLAPSES TO RUBBLE

PLAYER WOULD NOT HEED WARNINGS TO FLEE

HIS IDENTITY REMAINS UNKNOWN

A DRAMATIC & TROUBLING

CASE OF SUICIDE

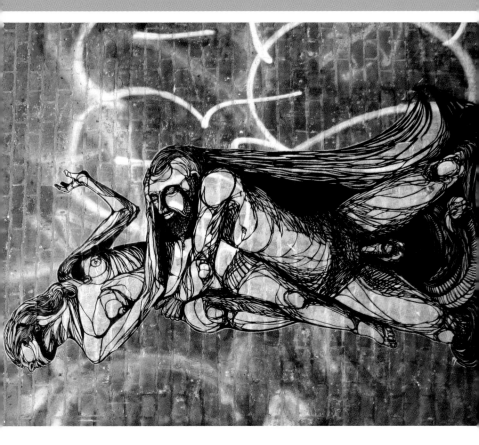

left
Imminent Disaster | New York City, New York, USA.
Photo by Ket

Imminent Disaster | Brooklyn, New York, USA.
Photo by Luna Park

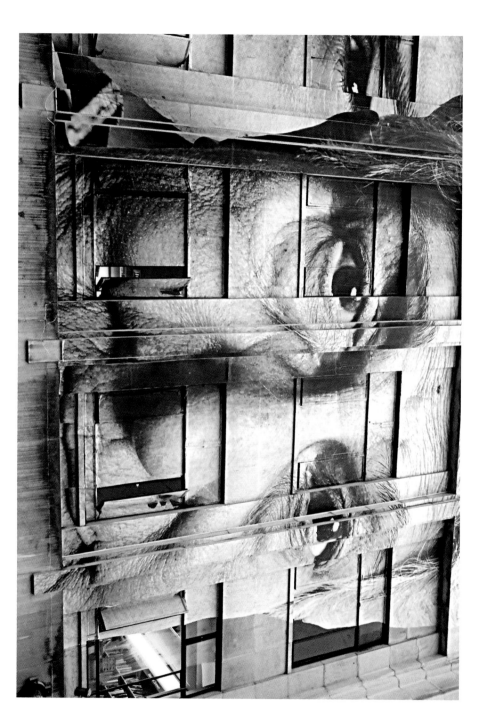

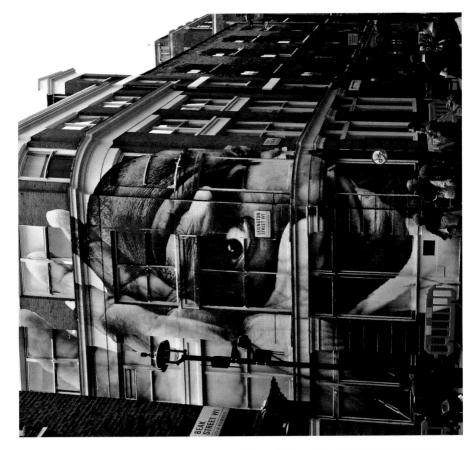

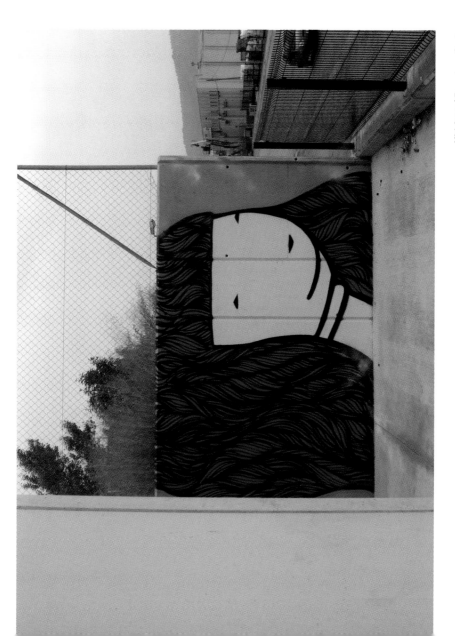

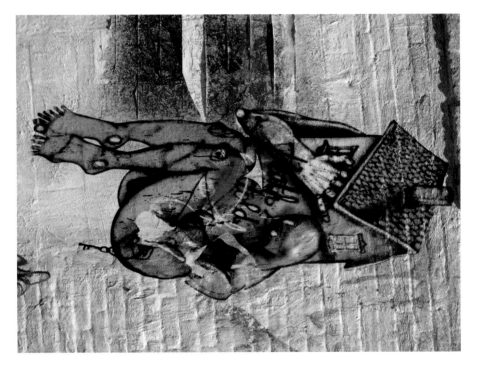

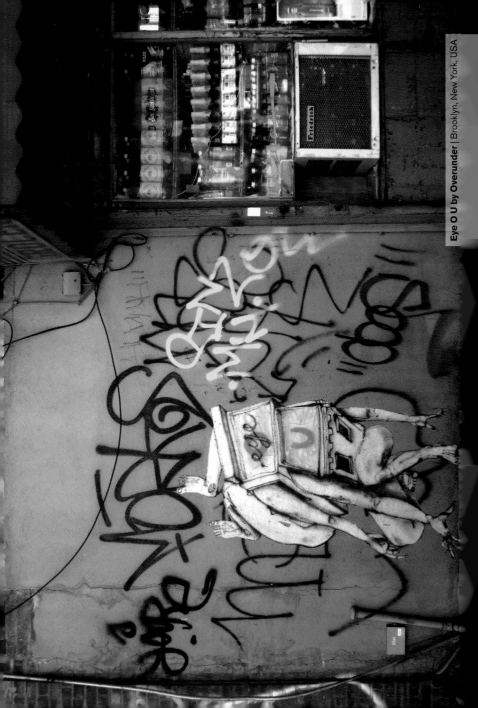

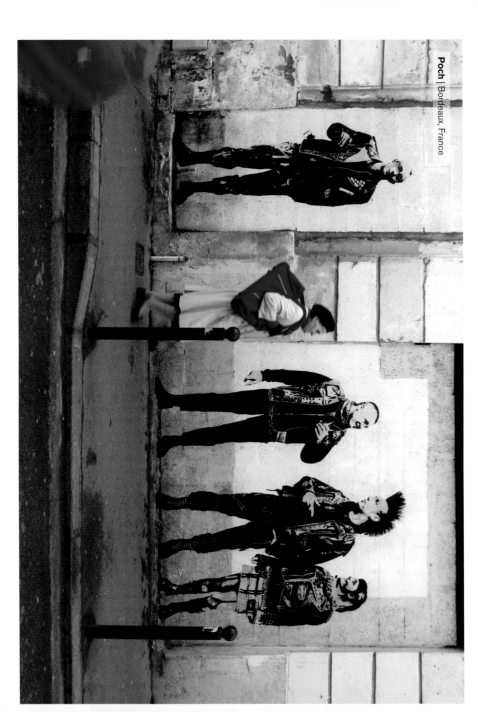

Poch | Bordeaux, France

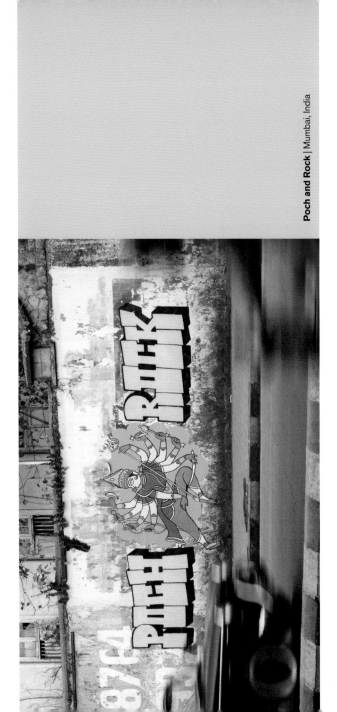

Poch and Rock | Mumbai, India

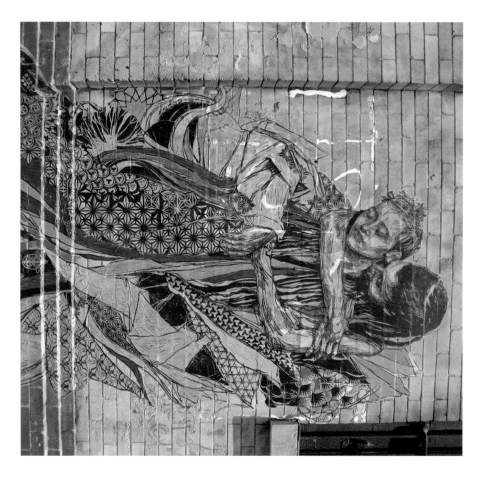

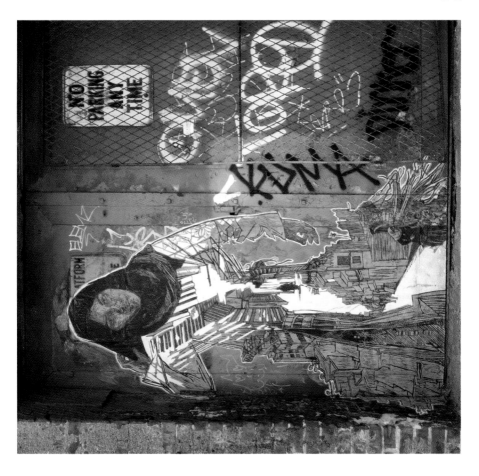

Swoon | Brooklyn, New York, USA.
Photo by Becki Fuller

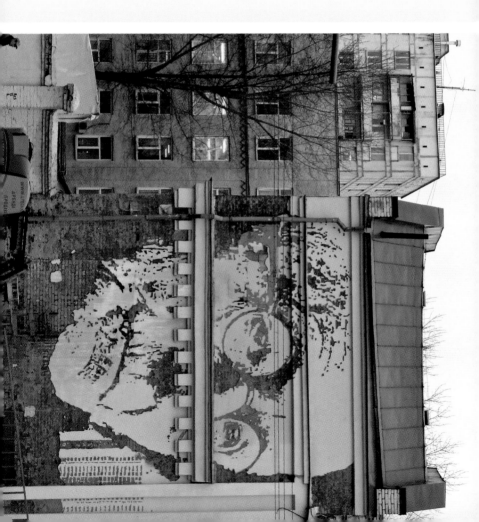

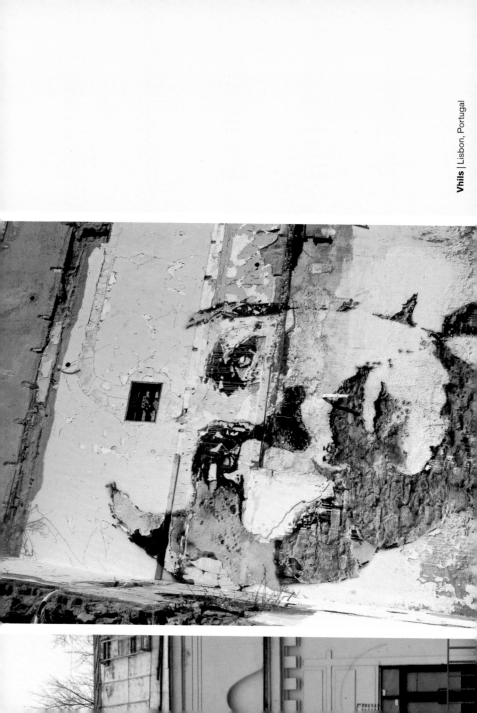

Vhils | Lisbon, Portugal

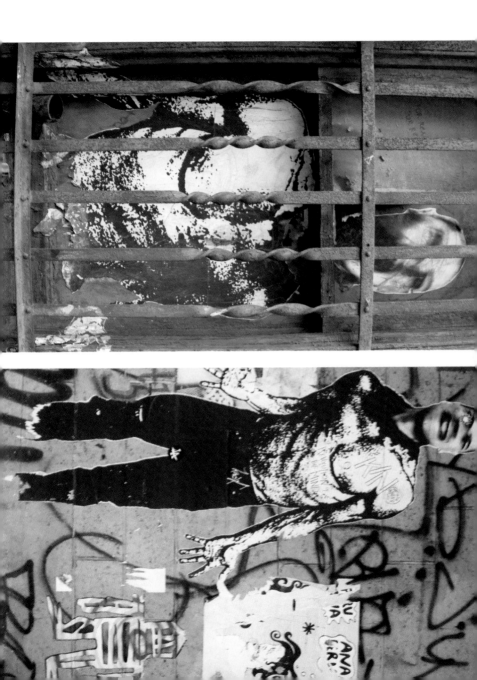

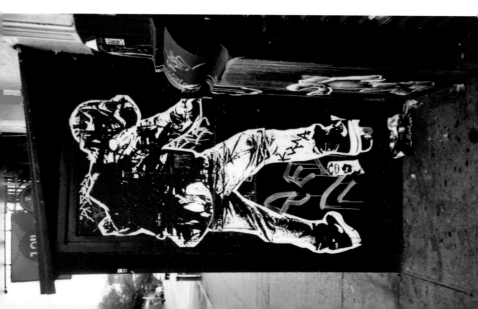

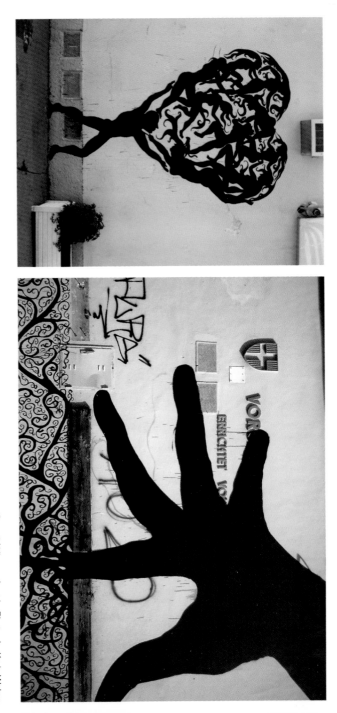

about the artists

1UP

1UP, one of the most prolific traditional graffiti crews in Berlin, specialize in street bombing and rooftops.

C215

French artist C215 is known for his realistic but stylized portraits of everyday people. He states, 'I start with a picture to end up with another, the one of my work painted outdoors, which is part of a framework while diverting it.'

Jef Aérosol

Stencil graffiti artist Jef Aérosol has been one of the main urban art proponents in France since the early 1980s. His subjects often include musicians like John Lennon and Bob Dylan.

Aiko

Aiko was born in Tokyo and has lived in New York since the mid nineties. A painter, graphic designer, filmmaker, jewellery designer and a dancer, Aiko incorporates floral designs, feminine cartoons and street pop culture images in her mixed-media works.

Aislap

The self-taught Chilean duo of Juan Moraga and Pablo Aravena are as much graffiti artists as they are muralists. Well known for their colourful murals, featuring fantastic characters and large-scale soft letter burners, over the past five years their work has taken over their home of Santiago, Chile.

André

André is a French graffiti artist who became widely known in the late nineties for cartoon character Mr A, which he used to draw in the streets of Paris. Distinguished by his poetic style and use of pink, he developed the 'Love Graffiti' series in the early 2000s.

Armsrock

Known for his life-sized works featuring humans at the edge of society, Armsrock glues or projects his drawings onto buildings and walls in urban environments. He states, 'as observations and statements they become ephemeral parts of public space and community'.

Aryz

Born in Palo Alto, California, Aryz moved to a town near Barcelona, Spain when he was three years old. His interest in graffiti began when he was in high school. In recent years he has exhibited in various Spanish and European Festivals and has appeared in some related books and magazines. His large paintings of monsters and other strangely grotesque cartoons can be found across the globe.

Banksy

Banksy is a British graffiti artist, painter, and political activist. His stencil technique is characterized by satire and dark humour. He travels widely, painting in anonymity, while his art serves as a commentary on the state of local and national affairs.

Basco Vasco

A Chilean street artist known for his Surrealist and Dadaesque works, Basco's style is exemplified by thick, black outlines that provide a stark contrast to the weathered walls on which he paints. He is a member of the graffiti crew Noko Kids.

Blek Le Rat

Born Xavier Prou in Paris, Blek Le Rat is a pioneer of the stencil graffiti technique. His works feature the homeless and downtrodden in society, as well as angels and self-portraits.

Blu

Blu is an Italian graffiti writer and muralist best known for using white house paint. His works take human figures to illustrate themes of corruption and can be found in Mexico City, Managua, Buenos Aires, Lima, Bethlehem, Bologna, and many other locations around the world.

Broken Crow

Broken Crow is a large-scale stencil-based mural painting team made up of Mike Fitzsimmons and John Grider. In 2005, while sharing a studio, the pair began to combine large stencils with the speed and spontaneity of street art. Their art features various animals and anthropomorphic humanoids in bizarre colours and extreme sizes. They live and work in St Paul, Minnesota.

Cakes

Jan Kaláb, also known as Cakes and Point, belongs to the oldest active generation of graffiti writers in the Czech Republic (DSK crew). In 2006 he graduated from the Academy of Fine Arts in Prague. Not only does he engage in classic graffiti, he also creates street art objects of various formats. In recent years his work has partially moved into a gallery setting, but his roots are fixed in urban environments.

D'Face

D'Face is a London-based former graffiti artist and designer turned street artist who uses stencils and posters to deliver his own brand of wit to the masses. His art consists of humorous and satirical characters.

Dolk

Dolk is a Norwegian stencil artist who began painting in the streets in 2003. His works are

humorous and often deal with sex, crime, and religion. He travels extensively, spreading his message.

Ben Eine
Ben Eine is one of London's most prolific and original street artists. Over twenty-five years ago he began as a writer, tagging London, and then developed a distinct typographic style. Eine specializes in producing huge letters on shop fronts across London.

Elbow-Toe
Elbow-Toe is a Brooklyn-based artist who has been creating introspective urban art for several years. Grounded in myth, symbolism and poetry his works are primarily executed in woodcut, stencil or large-scale charcoal drawings. He is particularly interested in the ability of environmental forces outside his control to create a timeless quality to the works.

El Mac
Mac has gained notoriety for his realistic depictions of both everyday people and ethereal women in his unique aerosol and brushwork styles. He often incorporates themes and techniques of classic art in a modern context.

Mac has been commissioned to produce murals around the world and has exhibited in gallery and museum shows from Belgium to Mexico.

Eltono
Eltono started producing graffiti in 1989 and by February 2000 was carrying out his first experiments with masking tape and acrylic paint, a technique that he has since used in almost all his work. He is known for his sensitivity to medium and location, choosing neglected surfaces with the intention of reviving their dignity.

Ema
Ema began spray-painting the walls of her hometown Montpellier, France in the early nineties. From wheatpastes in Brooklyn, to gallery shows in Chelsea and large-scale mural productions in Manhattan, Queens and the Bronx, Ema's artwork incorporates visual elements inspired from her daily life and the Brooklynite artist community.

Emol
Emol was born and raised in the Diadema suburb of São Paulo, Brazil. He is a self-trained artist who realizes urban interventions,

paintings, and sculptures. Emol is also a cultural producer creating projects that link art, culture, and education for the POVO organization (www. povo-povo.blogspot.com).

Faith47
Faith47 is a South African self-taught artist who draws inspiration from her own political and existential questions. Initially recognized for her unique graffiti and street art work, Faith is fast establishing herself internationally, showing in galleries and participating in projects across the globe.

Faile
Faile is the name used by the Brooklyn-based duo Patrick McNeil and Patrick Miller. For over ten years, Faile have plastered the streets of New York with posters, stencils and most recently totems.

Shepard Fairey
Fairey's OBEY campaign began in 1989 while he was a college student. Two decades later, he and his campaign are household names. He has bombed with stickers and posters from Los Angeles to Germany and even designed President Obama's campaign poster. His style

is easily recognized by its bold use of colours, lines, and imagery and is inspired by the Russian constructivism movement.

Gaia
Images of animals and people dominate Gaia's artwork, which is either hand-painted on site or developed in his studio. New York-based, he employs a combination of block printing, hand drawing and painting to create posters for the streets.

How and Nosm
Originally graffiti writers from Germany, the New York-based twins now experiment with abstract and figurative murals. In their latest works they use a limited colour pallet of red, black and white.

Iemza
French artist Iemza's murals display white figures of primitive man or fantastical aliens with exaggerated limbs and breasts, providing a stark contrast to their remote and abandoned locations.

Imminent Disaster
Imminent Disaster lives and works in Brooklyn

where she creates large installations in the streets as well as in galleries. Her exterior installations, destined to an inevitable destruction, are inspired by styles of urban construction.

Insa
Insa is a fine artist and designer who has established himself in graffiti circles through extensive street-level work and gallery shows. Throughout his career, he has explored different approaches and outlets for his artistic agenda, including designing signature collections for brands such as Kangol, Kid Robot and Oki-Ni, as well as starting his own heel company, Insa Heels.

JR
JR exhibits his photography as street art throughout the world, enlarging his images of local citizens and pasting them on city walls. His projects can be seen in the Favelas of Rio de Janeiro, in China and on trains in Kenya.

Kegr
The Copenhagen-based graffiti writer has been active for over twenty years, painting everything from pieces and throw-ups to tags. Most

recently he has taken to painting large-scale messages high up on the sides of buildings.

Kenor
The son of a Sevillian painter and photographer, Kenor emerged on the street art scene in the late eighties. He transported his art to L'Hospitalet and later Barcelona on walls and trains, in the form of free and moving art, and is fascinated by typography and logos.

Kid Acne
Kid Acne's career began with an appearance on *Rolf's Cartoon Club* at the age of twelve. Within a year, he'd started writing graffiti. With a small group of friends, he spent his teenage years making underground fanzines and limited run 7"s on their Invisible Spies imprint. His wheatpastes and rap-sprays can now be seen throughout the world. He lives and works in Sheffield, England.

Know Hope
For the past five years, Know Hope has been showcasing his work in exhibitions worldwide, but mainly on the streets, in its natural urban setting. The work deals with a need for momentary connections in mundane reality, and

the common denominator that is the human struggle. Through site-specific installations, murals and paste-ups, Know Hope attempts to create situations that happen in real time and are accessible to the public on a day-to-day basis.

Augustine Kofie

Active since 1993, Kofie's abstract and minimalist works can be found on the streets of his native Los Angeles and hidden in abandoned factories.

Limpo

Fabio da Rocha, also known as Limpo, was born in Salvador da Bahia, Brazil. After being inspired by graffiti at the age of fifteen, he soon discovered his passion for designing his own street art. His figures are often barefoot, some carry children and others berries; they are always sad.

Anthony Lister

Anthony Lister is an Australian-born painter and installation artist living and working in Brooklyn. His art, both on the street and in galleries, has earned him an international following. Often mixing spray paint and brush strokes on the same canvas, Lister's paintings offer a playful reflection of our media-saturated world and often deal with dethroned heroes.

Lunar

Lunar Kosanovi is a Zagreb-based artist who emerged from the early Croatian graffiti scene painting, exhibiting and publishing his works worldwide. *Playboy, Outdoor Advertising Magazine, Forbes* magazine, Nissan and Coca-Cola are among his clients.

Mosko et Associés

Mosko et Associés are Michel Allemand and Gérard Laux. The duo has been working together for approximately fifteen years covering Parisian walls with their beautiful multicoloured animals.

The London Police

Active for over ten years, The London Police aim to rejuvenate the streets of Amsterdam with their black and white characters, offering a lighthearted contrast to the tags and posters found elsewhere in the city.

Barry McGee

McGee is a graffiti artist who has been working on the streets of the USA since the eighties, known by the tag name 'Twist'. A much-respected cult figure in the skate, graffiti, and West Coast surfer community, he was born in 1966 in California, where he continues to live and work. His mural styles range from classic throw-ups on a massive scale to walls filled with monochromatic tag signatures, characters, and geometric patterns.

Morcky

Amsterdam-based Morcky's murals interact with the surrounding walls and structures. No longer painting standard graffiti, his art still contains the boldness and energy that he once channelled as a writer in Italy.

Neck Face

Neck Face is known for a mixture of heavy metal-style characters and satanic messages. His tags are often humourous and are written in a legible style.

Nunca

Francisco Rodrigues da Silva, aka Nunca, is a Brazilian artist who uses graffiti to create images that unite modern urban Brazil with its native past. Nunca uses a mesh technique to

recreate scenes of Native Brazilian and Afro-Brazilian figures in the streets and on canvas.

Os Gêmeos

Os Gêmeos (Portuguese for 'The Twins') are internationally known graffiti artists from São Paulo, Brazil. Their work often features yellow lettering and yellow-skinned characters with subjects ranging from portraits to blockbuster pieces, as well as Brazilian folklore. Their graffiti style is both influenced by traditional hip-hop style and the Brazilian pixação movement.

Overunder

Overunder lives in an imaginative and handmade cabin in the centre of Brooklyn where he paints pictures of people living in equally imaginative and handmade buildings. These images can be found wheatpasted throughout Brooklyn, in his hometown of Reno, Nevada, as well as in Gambia, Africa.

Peace

Peace's mythical and ancient birds can be seen throughout Salvador, Brazil. He frequently collaborates with graffiti writers, using his characters to embellish their pieces.

Pesimo

Pesimo began writing graffiti in 1988 and as a member of the DMJC (Peru's first graffiti crew) is one of the leading artists in both the graffiti and street art movements in Lima. His art is influenced by the routine and transient lives of the city's inhabitants and his figures are depicted with hardened poses and features exemplifying their daily struggle.

Poch

Influenced by the punk-rock scene from an early age, Patrice Poch made his first stencil in 1988. After discovering the hip-hop movement and graffiti, he began painting on walls and trains of the Parisian suburbs. In the late nineties, he followed a more minimalist direction. He now displays acrylic paint logos, collages in situ, stencils and posters.

Retna

While still in high school, Retna led one of the largest and most innovative graffiti art collectives Los Angeles has witnessed. He is perhaps best known for appropriating fashion advertisements and amplifying them with his unique layering, intricate line work, text-based style and incandescent colour palette.

Roa

Based in Ghent, Belgium, Roa is renowned for his giant black and white animals. Roa began painting abandoned buildings and warehouses in the isolated industrial areas of his hometown. Since then, his work has been seen in New York, London, Berlin, Moscow and Paris.

San

Active on the streets of his native Moraleja since 1993, Spanish graffiti writer and muralist San breathes new life into the old buildings that act as his canvasses.

Sam3

Born in Elche, Spain, Sam3 currently lives and works in Madrid. His murals, often ironic, feature black silhouettes placed in urban surroundings.

Chris Stain

Baltimore-born and New York-based, Chris Stain focuses on stencil work, incorporating themes of social realism from US working-class and inner-city life.

Sten and Lex

Sten and Lex have been stencilling the

streets of Rome and other European cities since 2000. Also know for their hand-painted posters, many of their works are inspired by religious imagery. Most recently they have produced portraits from photographs that are painted on wood in black, white and halftones.

Swoon

Swoon is a street artist from New York who specializes in life-size wheatpaste prints and paper cut-outs of figures.

Vhils

Portuguese-born Vhils creates large-scale wheatpaste posters that focus on the idea that nothing lasts forever; the constant transformation of art and community is ever present in his work.

Nick Walker

British stencil artist Nick Walker is known for humorous images that combine photographic elements with conventional graffiti styles. Stencils 'allow me to take an image from anywhere – dissect any part of life – and recreate it on any surface,' he states.

WK Interact

Born in 1969 in Caen, France, WK currently lives and works in New York. His technique of twisting an original drawing or photograph, while it's being photocopied, results in the monochromatic palette and streamlined moment-in-time appearance of his finished work. WK finds appropriate locations then chooses his imagery with a view to creating interactions in an urban environment.

Zezão

A self-taught artist from São Paulo, Brazil, Zezão is known for his works in the sewers and homeless areas of his native city. His trademark pallet of blue shades provides a stark contrast to the squalid surroundings in which he paints.

about the author

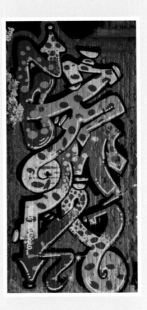

Ket's career began at the age of fifteen when he started taking photographs of the striking subway trains in Brooklyn. Since then, his pictures have graced the pages of many media outlets, including *Rolling Stone*, *The Sunday Telegraph*, *The New York Times Magazine*, *The Source* and *Stress*.

At seventeen, Ket was no longer content merely to document graffiti art; he wanted to create it as well. Once he perfected his tag, he quickly became a well-known graffiti writer both on the New York City subway lines and internationally. His painting has taken him around the world, where he has exhibited in major cities such as Munich, Berlin and Copenhagen as well as documenting the graffiti movements there.

Today, he is active in his New York City community as a producer, writer, graffiti historian, photographer, painter and graffiti advocate.

You can read his blog on www.12ozprophet.com and learn about his organization at www.thewallsbelongtous.com.

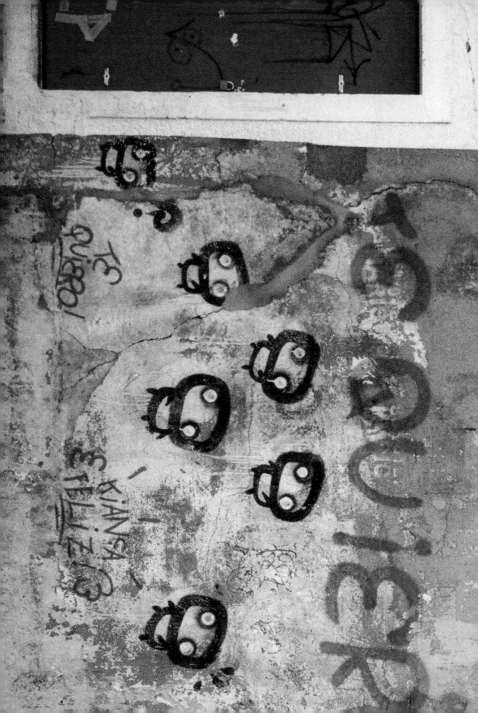